MLK
A CELEBRATION
IN WORD
AND IMAGE

MARTIN LUTHER KING, JR.

Introduction by CHARLES JOHNSON

Edited by BOB ADELMAN

BEACON

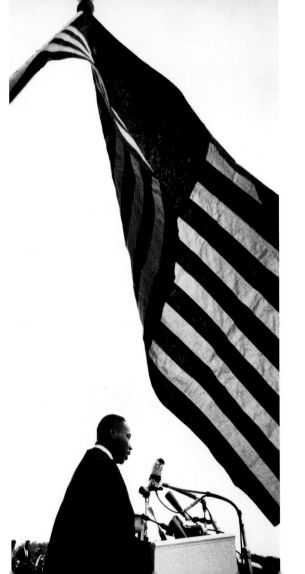

Photography Editor **Bob Adelman**
Art Director **Rick DeMonico**
Digital Imaging **Stephen Watt**

Beacon Press
25 Beacon Street
Boston, Massachusetts 02108-2892
www.beacon.org

Beacon Press books are published under the auspices of
the Unitarian Universalist Association of Congregations.

Introduction

An example of the richness and complexity of the life and legacy of Dr. Martin Luther King, Jr., was on display August 28, 2010, at the National Mall on the forty-seventh anniversary of his "I Have a Dream" speech. Conservative talk-show host Glenn Beck held a controversial "Restoring America" rally at the Lincoln Memorial, an event at which the great civil rights leader's niece, Dr. Alveda King, was a featured speaker who emphasized the importance of traditional American values. At the same time, the Reverend Al Sharpton organized a counter-rally called "Reclaiming the Dream" just a few miles away in Washington's black Shaw neighborhood, where Martin Luther King III decried economic inequality and protestors marched to the future site of the Martin Luther King, Jr., memorial. In those two events we saw a nation divided. And a family divided. Yet both rallies expressed the views of Martin Luther King, Jr. How could one man's legacy be so capacious, and his life such a cornucopia of ideas, that forty-two years after his death they produce dueling events in his name?

The answer to that question can be found in the fact that during his thirteen-year public ministry and world-transforming journey from Montgomery to Memphis, Dr. King was not only a powerful agent for change but always changing himself, ever seeking to improve and refine his vision, though people have a tendency to freeze the process of his journey into a single conceptual frame, or to cherry-pick whatever they prefer to highlight about his life. Liberals and conservatives alike, Democrats and Republicans, Louis Farrakhan of the Nation of Islam, and even pro-gun advocates in Washington State cite his words to support their vastly differing political agendas. To be sure, this is often the case with "world-historical" men and women who transformed the way we live and see the world. For example, Beck's rally was held in the shadow of a White House occupied by Barack Obama, this country's first black president, whose victory in 2008 is unthinkable without the impact King had on America.

What we must remember is that while there is unity, coherence, and consistency in King's vision, his social philosophy evolved through three stages during his political and spiritual odyssey.

As the dramatic and now iconic images in this book by esteemed civil rights photographer Bob Adelman and others demonstrate, King in that first stage is a newly minted PhD, a twenty-six-year-old idealist, a husband and father holding down his first job as pastor at Dexter Avenue Baptist Church when he is thrust into leadership of the Montgomery Bus Boycott by the courageous refusal of Rosa Parks to acquiesce to segregation.

In that battle, and in so many others that followed, culminating in the electrifying Birmingham campaign and legislative triumph of the Civil Rights Act of 1964, he places his unique stamp on black America's 336-year-old liberation struggle by emphasizing, in Gandhi-esque fashion, the importance of nonviolent civil disobedience and that our ultimate goal should not be desegregation of lunch counters but instead the realization of a "beloved community." Equally important as nonviolence and integration for King is the idea of *agape*, our strength to love. In this period, he emerges as that rarest kind of revolutionary, one demanding that whites live up to the ideals proclaimed in their most sacred, secular documents (the Declaration of Independence and Constitution) and that black people lift themselves to new levels of excellence in character and moral perfection.

Despite violent attacks from whites and blacks, despite the days he spent in jail, where he composed "Letter from Birmingham Jail," one of the most important political documents in American history, King's sacrifices and leadership hastened the end of this country's version of apartheid. Some felt he should stop at this stage, after his soaring "I Have a Dream" speech, and quietly return to his life as co-pastor in his father's church in Atlanta, or perhaps accept a position as a college president.

But when King received the Nobel Peace Prize, he was thrust onto the world stage, and entered a second phase in his development. He reflected deeply upon, and then fully embraced, the implications of nonviolence as a way of life for both individuals and nations, and upon his own new role as a global ambassador for peace. Logically and inevitably, his commitment to the "beloved community" encompassed the entire planet, transcending national boundaries. That made it necessary for King to oppose America's war in Vietnam, even though his taking this position led some members of the Movement, as well as the press and President Lyndon

Baines Johnson, to question whether King had abandoned his true mission when he became one of the first nationally prominent figures to actively protest America's ill-fated adventure in Southeast Asia.

The truth is that King was thinking more deeply, more consistently, than his opponents. He recognized how, in an interconnected world best described as an "inescapable network of mutuality," this divisive, political war was draining resources needed to solve domestic problems. And he saw, too, toward the end of his life, as he examined the obstacles to a "beloved community," that questions of social equality could not be resolved unless he also addressed the problem of economic inequality.

Thus, King entered his third and final stage—one might call this Christian socialism—as an advocate for all those who were impoverished in the wealthiest nation on earth, devoting his final days to supporting black sanitation workers in Memphis and preparing for a Poor People's Campaign that, in April 1968, would have brought three thousand poor people to the nation's capital. He spoke in this phase of his life of a Bill of Rights for the Disadvantaged, and he championed A. Phillip Randolph's Freedom Budget, a domestic Marshall Plan that might correct the flaws of capitalism. But, tragically, at the age of thirty-nine, an assassin's bullet brought him down, ending act three of his evolution when it had barely begun.

Citizen King, therefore, was prismatic, multifaceted, and even today we have not measured all the aspects of our lives—politically, spiritually, and socially—revolutionized by his passage among us. His philosophy and political deeds are all of a piece. But, unlike people who select the fragments of King's life that they prefer, this beautiful book presents the moving, inspiring biography of one of twentieth-century America's most influential citizens in all his fullness.

Charles Johnson
Seattle, 2010

"I grew up in a family where love was central and where lovely relationships were ever present. It is quite easy for me to think of the universe as basically friendly, mainly because of my uplifting hereditary and environmental circumstances."

— From "An Autobiography of Religious Development," essay written at Crozer Theological Seminary, November 22, 1950

An early photograph from the King family album. Standing are, from left to right, Martin Luther King, Jr.'s mother, father, and maternal grandmother. Seated are Alfred Daniel, Christine, and Martin. Circa 1938. (Photograph by © Benedict J. Fernandez)

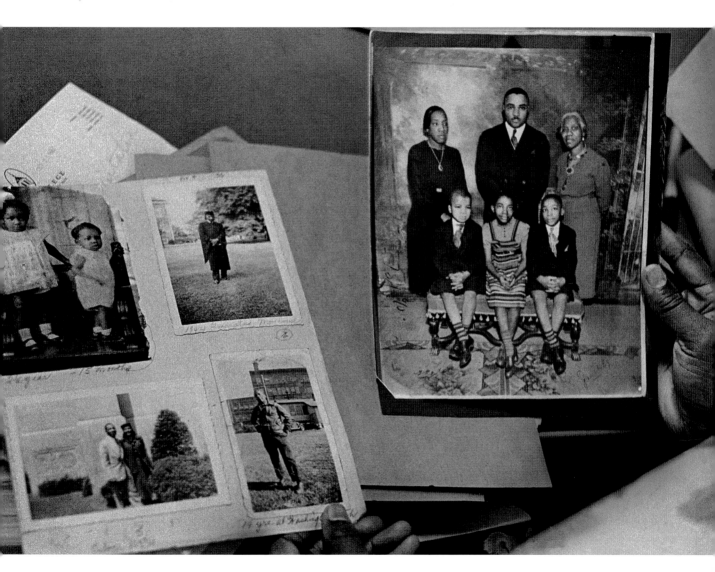

"If you will protest courageously, and yet with dignity and Christian love, when the history books are written in future generations, the historians will have to pause and say, 'There lived a great people—a black people—who injected new meaning and dignity into the veins of civilization.'"

— From speech to supporters of the
Montgomery Bus Boycott, Holt Street
Baptist Church, Montgomery, Alabama,
December 5, 1955

While leading the Montgomery Bus Boycott, proud pastor and new father MLK, accompanied by his wife, Coretta, shows off his baby daughter, Yolanda, outside Dexter Avenue Baptist Church, Montgomery, Alabama, 1956.

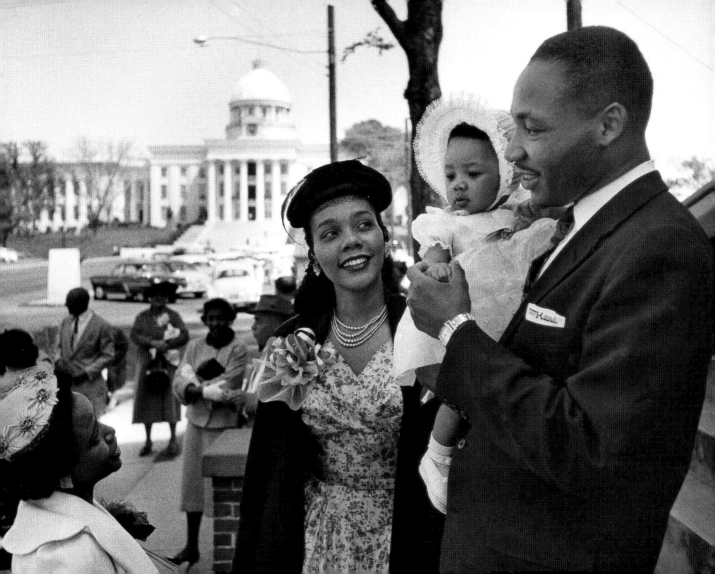

"Christ furnished the spirit and motivation, while Gandhi furnished the method."

— From *Stride Toward Freedom*, 1958

Arrested for the second time for leading the Montgomery Bus Boycott, MLK sits for a mug shot. Montgomery, Alabama, 1956.

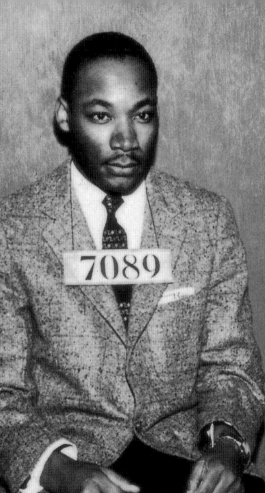

"Ordinarily a person leaving a courtroom with a conviction behind him would wear a somber face. But I left with a smile. I knew that I was a convicted criminal, but I was proud of my crime."

— From *Stride Toward Freedom*, 1958

Outside the Montgomery courthouse, the Kings with their followers celebrate his conviction for conspiracy-to-boycott, which he believed to be an unjust law. Montgomery, Alabama, 1956.

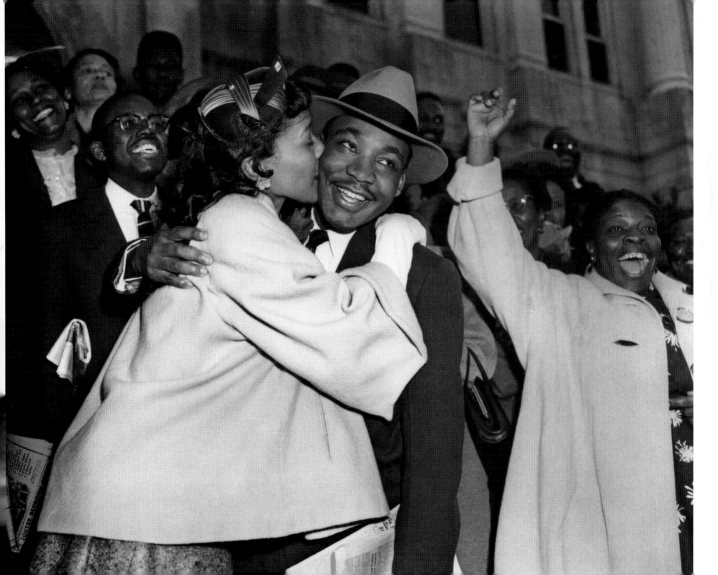

"We come humbly to say to the men at the forefront of our government that the civil rights issue is . . . an eternal moral issue which may well determine the destiny of our nation. . . . So long as I do not firmly and irrevocably possess the right to vote, I do not possess myself."

— From "Give Us the Ballot," address given at the Prayer Pilgrimage for Freedom, Lincoln Memorial, Washington, D.C., May 17, 1957

Speaking at the Prayer Pilgrimage for Freedom in front of the Lincoln Memorial in 1957, MLK calls for black suffrage.

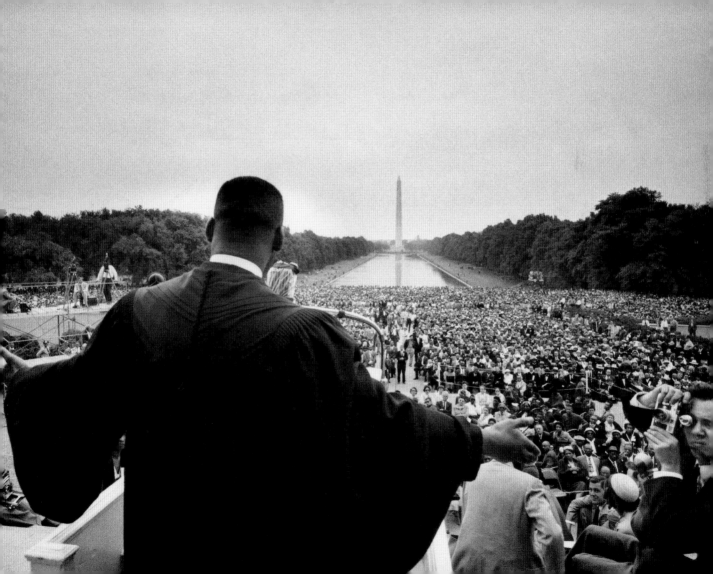

"There must be a recognition of the sacredness of human personality. . . . Every human being has etched in his personality the indelible stamp of the Creator."

— From "The Ethical Demands for Integration," speech given at a church conference, Nashville, Tennessee, December 27, 1962

People always seemed to want to reach out and shake MLK's hand. The crowd at the Prayer Pilgrimage was so enthusiastic, police had to step in and escort MLK to safety. Washington, D.C., 1957.

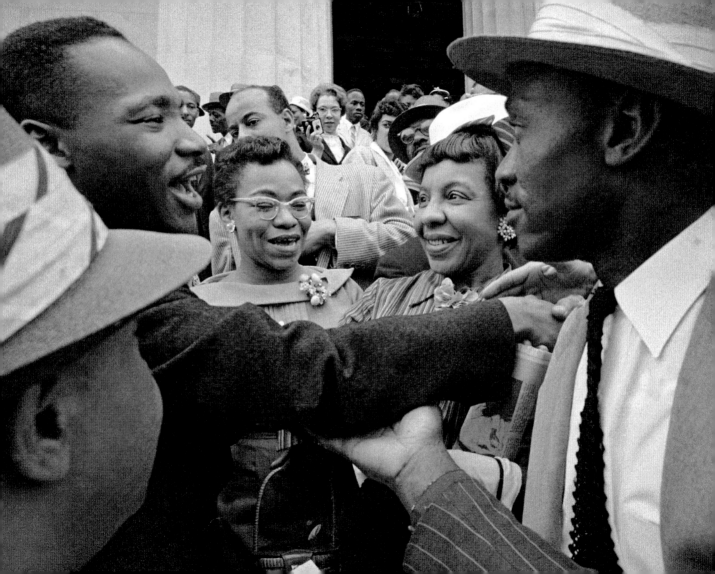

"Don't do anything to her; don't prosecute her; get her healed," MLK said of his attacker.

— At Blumstein's Department Store,
New York City, September 20, 1958

While MLK was promoting his new book, a woman walked up to him and asked, "Are you Dr. King?" "Yes I am," he said. She then drove a seven-inch letter opener into his chest. Here, a woman tends to King, who had cut his hand trying to remove the blade. New York City, September 1958.

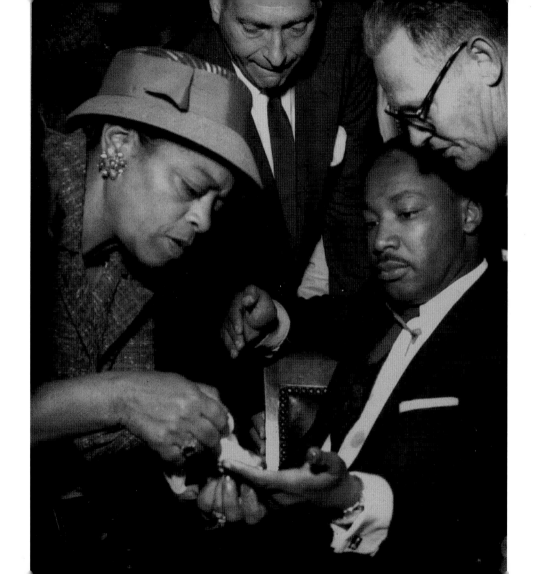

"We cannot solve this problem through retaliatory violence. We must meet violence with nonviolence. . . . We must meet hate with love."

—From *Stride Toward Freedom*, 1958

MLK removes a charred cross from his front lawn as his son Marty watches. The previous night, April 25, 1960, crosses had been burned at many black homes in Atlanta. Ku Klux Klan Night Riders burned crosses to intimidate, frighten, and warn blacks intent on asserting their rights.

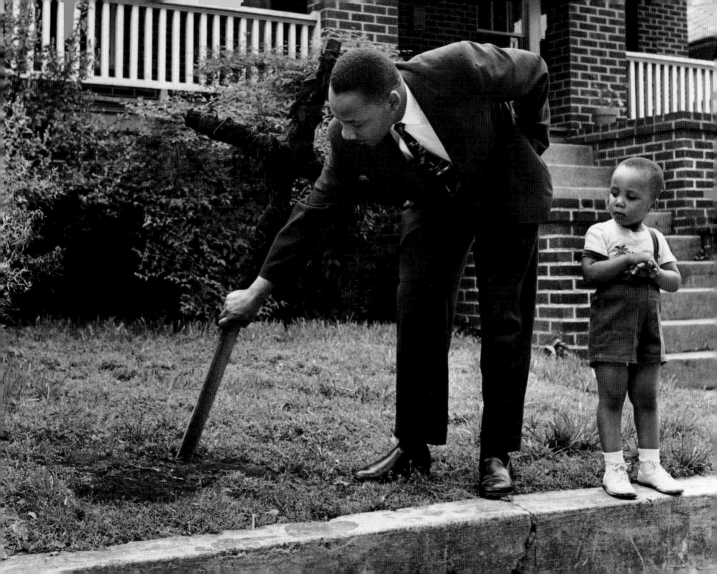

"We must work on two fronts. On the one hand, we must continue to resist the system of segregation which is the basic cause of our lagging standards; on the other hand, we must work constructively to improve standards themselves. There must be a rhythmic alteration between attacking the causes and healing the effects."

—From *Stride Toward Freedom*, 1958

MLK, a PhD in theology, at work in his study at the Ebéne-zer Baptist Church. He devoted a major part of his life to composing weekly sermons and writing articles, columns, speeches, and six books. Atlanta, date unknown.

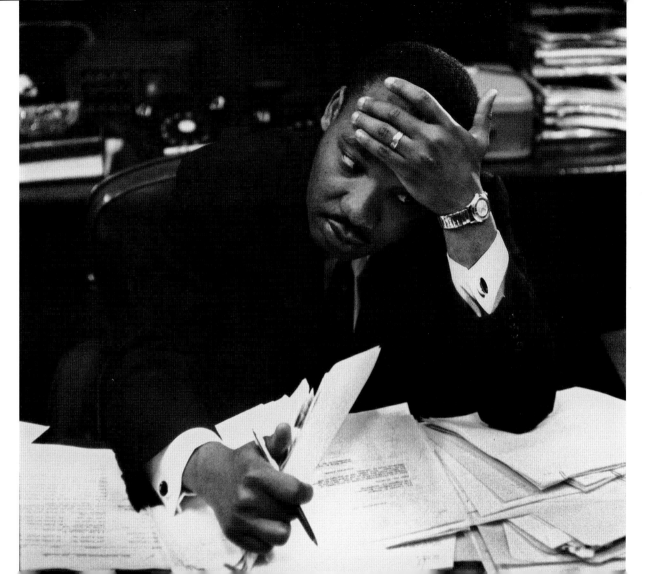

"The family often used to ride with me to the Atlanta airport, and on our way, we always passed Funtown, a sort of miniature Disneyland . . . Yolanda would inevitably say, 'I want to go to Funtown.' . . . One of the most painful experiences I have ever faced was to see her tears when I told her Funtown was closed to colored children, for I realized that at that moment the first dark cloud of inferiority had floated into her little mental sky, that at that moment her personality had begun to warp with that unconscious bitterness toward white people. . . . But it was of paramount importance to me that she not grow up bitter. . . . Pleasantly, word came to me later that Funtown had quietly desegregated, so I took Yolanda. A number of white persons there asked, 'Aren't you Dr. King, and isn't this your daughter?' I said we were, and she heard them say how glad they were to see us there."

— From *Playboy* interview: Martin Luther King, Jr., January 1965

The King family at home: Yolanda, Coretta, Bernice, MLK, Dexter, and Martin III. Atlanta, 1964.

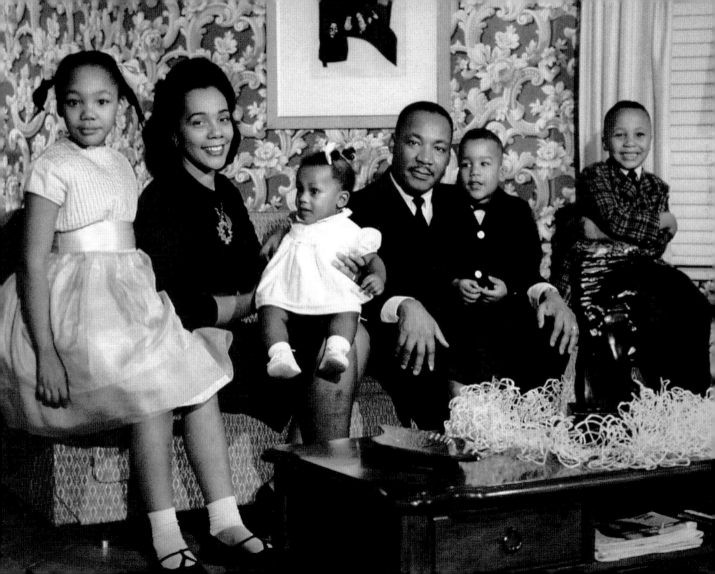

"The system we live under creates people such as this youth. I'm not interested in pressing charges. I'm interested in changing the kind of system that produces such men."

— From "Martin Luther King, Jr.: Rare Photos at Home," *Life* magazine, 1962

MLK and his wife share a tense moment at home. Coretta had just learned that her husband was attacked the night before by a disturbed white racist in Birmingham and refused to press charges. Coretta worries her husband is defenseless and has so many enemies. Atlanta, 1962.

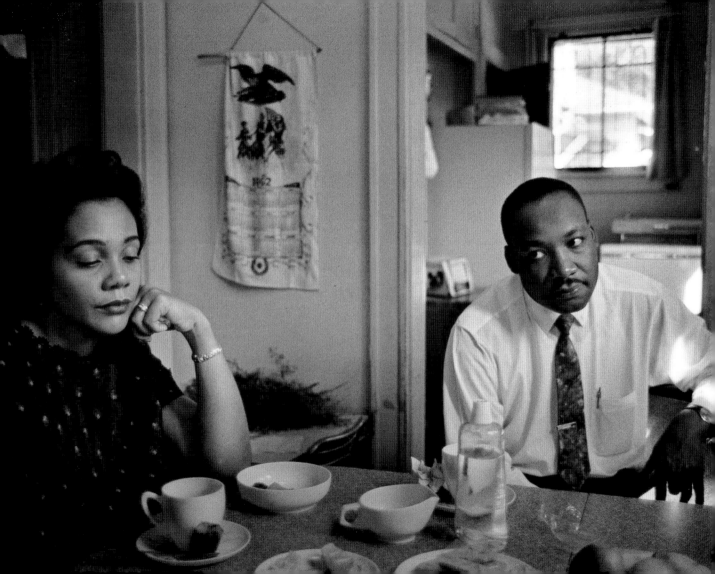

"*I have been tortured without and tormented within by the raging fires of tribulation. . . . I have been forced to muster what strength and courage I have to withstand howling winds of pain and jostling storms of adversity. But as the years have unfolded the eloquently simple words of Mother Pollard have come back again and again to give light and peace and guidance to my troubled soul: 'God's gonna take care of you.'*"

— From *Strength to Love*, 1963

Mother Pollard was one of the oldest and most dedicated of the Montgomery Bus Boycott participants. King cites her words one Sunday during an electrifying sermon to his parishioners. Atlanta, 1963.

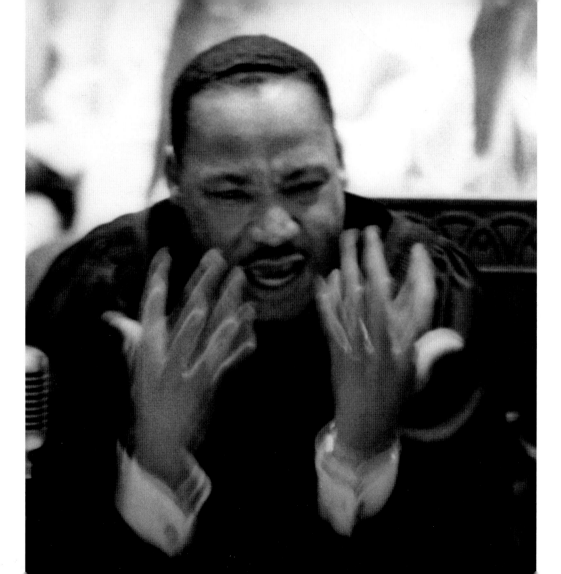

"You would have found a general atmosphere of violence and brutality in Birmingham. Local racists intimidated, mobbed and even killed Negroes with impunity. No Negro home was protected from bombings and burnings. . . . You would be living in the largest city of a police state, presided over by a governor—George Wallace—whose inauguration vow had been a pledge of 'segregation now, segregation tomorrow, segregation forever!' You would be living, in fact, in the most segregated city in America."

— From "Letter from Birmingham Jail," in *Why We Can't Wait*, 1963

Speaking at an organizing rally, MLK calls on those joining the protest to wear overalls until Easter to show their solidarity with the people boycotting Birmingham's segregated stores. Blue denim overalls were traditionally worn by sharecroppers. Birmingham, Alabama, 1963.

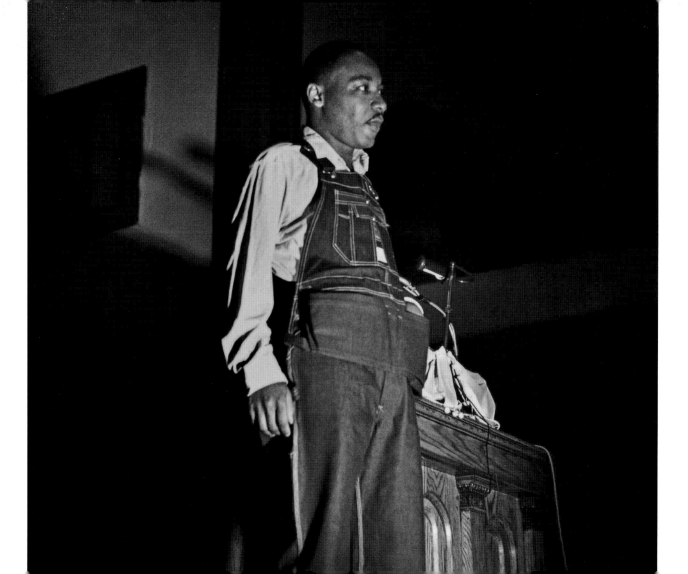

"Any law that uplifts human personality is just. Any law that degrades human personality is unjust."

— From "Letter from Birmingham Jail,"
in *Why We Can't Wait*, 1963

After his arrest, MLK stays in jail, where he wrote his
impassioned "Letter from Birmingham Jail," countering the
protests by religious critics. Birmingham, Alabama, 1963.

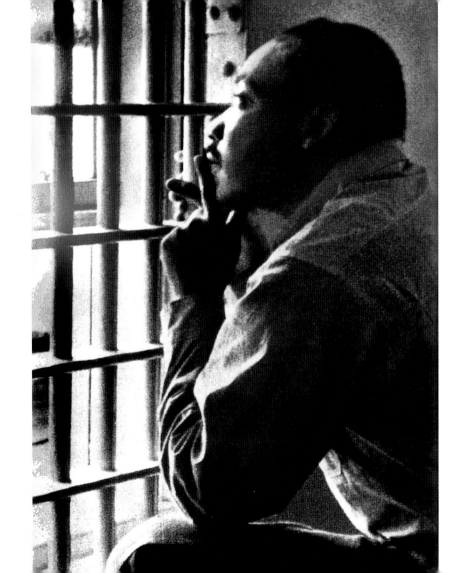

"Five score years ago, a great American, in whose symbolic shadow we stand today, signed the Emancipation Proclamation. . . . But one hundred years later, the Negro still is not free. One hundred years later, the life of the Negro is still sadly crippled by the manacles of segregation and the chains of discrimination. One hundred years later, the Negro lives on a lonely island of poverty in the midst of a vast ocean of material prosperity. One hundred years later, the Negro is still languishing in the corners of American society and finds himself an exile in his own land."

— From "I Have a Dream," speech given at March on Washington for Jobs and Freedom, Lincoln Memorial, Washington, D.C., August 28, 1963

MLK, fresh from his momentous victory in Birmingham, leads marchers from the Washington Monument to the Lincoln Memorial, kicking off the largest protest rally in the nation's history. He grabs the hand of Floyd McKissick of CORE and the arm of a clergyman. Washington, D.C., 1963.

"I have a dream that one day on the red hills of Georgia, the sons of former slaves and the sons of former slave owners will be able to sit down together at the table of brotherhood. I have a dream that one day even the state of Mississippi, a state sweltering with the heat of injustice, sweltering with the heat of oppression, will be transformed into an oasis of freedom and justice. I have a dream that my four little children will one day live in a nation where they will not be judged by the color of their skin, but by the content of their character."

— From "I Have a Dream," speech given at March on Washington for Jobs and Freedom, Lincoln Memorial, Washington, D.C., August 28, 1963

At the climax of his "I Have a Dream" speech, MLK, the final speaker at the march, raises his arm and calls out for deliverance with the electrifying words from an old spiritual, "Free at last! Thank God Almighty, we are free at last!" Washington, D.C., 1963.

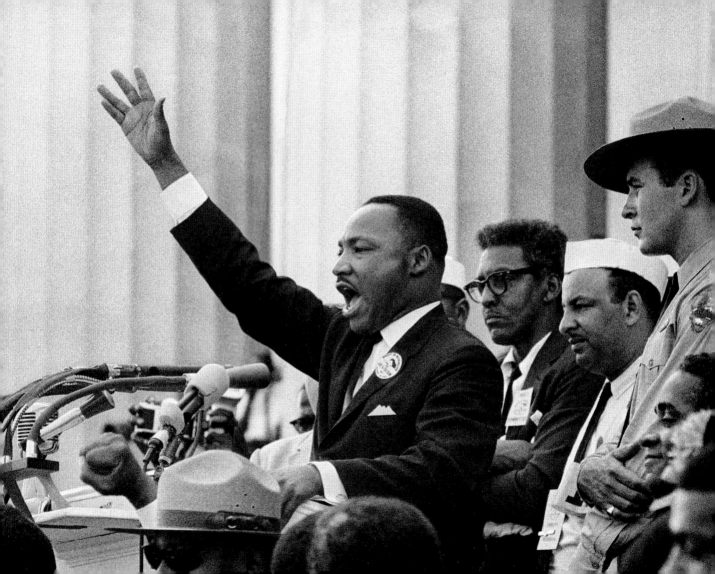

"Nonviolence is the answer to the crucial political and moral questions of our time. . . . The foundation of such a method is love. . . . I have the audacity to believe that peoples everywhere can have three meals a day for their bodies, education and culture for their minds, and dignity, equality, and freedom for their spirits."

— From the speech delivered in acceptance
of the Nobel Peace Prize, Oslo, Norway,
December 10, 1964

MLK quietly regards his Nobel Peace Prize medallion.
Selflessly, he donated the award check proceeds to all the
militant groups opposing racism. Oslo, Norway, 1964.

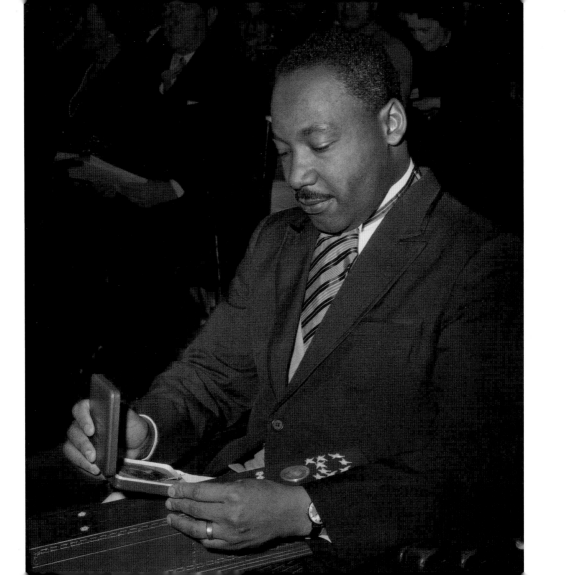

"We must come to see that the end we seek is a society at peace with itself, a society that can live with its conscience, and that will be a day not of the white man, not of the black man. That will be the day of man as man."

— From "Our God Is Marching On!," speech given at the conclusion of the Selma to Montgomery march, Montgomery, Alabama, March 25, 1965

An unshaven MLK meets colleagues after he is released from jail. The escalation of confrontations and the jailings, along with MLK's responsibilities, visibly strain him. At that time, only 1 percent of the blacks in Selma were registered to vote, although they made up half of the population. Selma, Alabama, 1965.

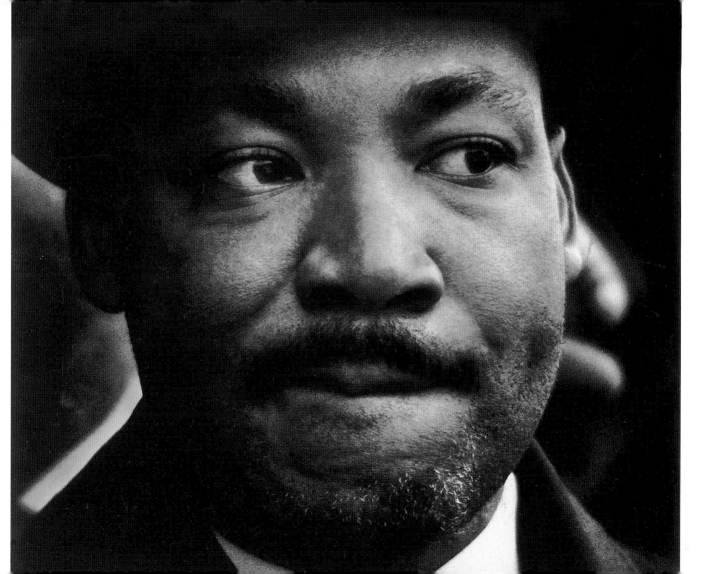

"And so in his death, Jimmie Jackson is saying something to each of us, black and white alike. He's saying that we must substitute courage for caution. . . . His death says to us that we must work passionately and unrelentingly to make the American dream a reality."

— From eulogy for Jimmie Lee Jackson, audio
provided by the Martin Luther King, Jr.,
Research and Education Institute, March 3, 1965

As the protests increase, demonstrators begin to hold night marches in neighboring counties. At one such march, a young black man, Jimmie Lee Jackson, is shot down by the police as he was protecting his family. At Jackson's burial, MLK expresses his hope that love will conquer hate through justice. Marion, Alabama, 1965.

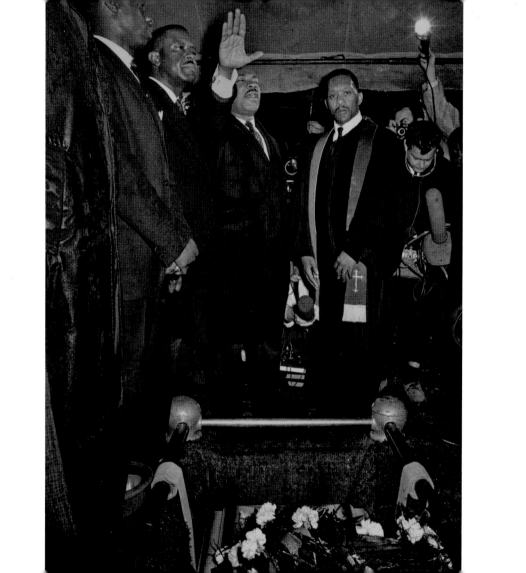

"Oh, deep in my heart I do believe we have overcome today!"

— King's revised lyrics to the traditional
song "We Shall Overcome," the anthem
of the civil rights movement

As MLK and Coretta lead the singing, three thousand
marchers follow behind. The historic fifty-four-mile march
from Selma to Montgomery is the greatest display of the
power and dignity of nonviolent protest since Gandhi's Salt
March to the sea. Outskirts of Montgomery, Alabama, 1965.

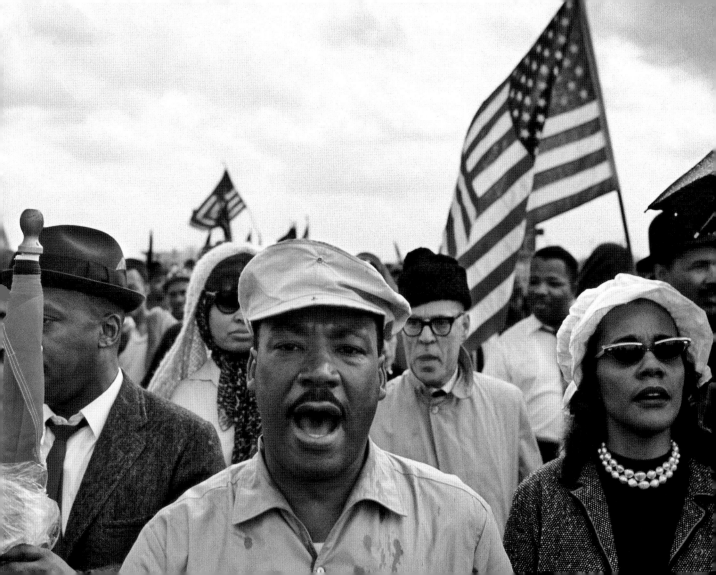

"Our whole campaign in Alabama has been centered around the right to vote. In focusing the attention of the nation and the world today on the flagrant denial of the right to vote, we are exposing the very origin, the root cause, of racial segregation in the Southland. . . . The threat of the free exercise of the ballot by the Negro and the white masses alike resulted in the establishment of a segregated society. They segregated Southern money from the poor whites; they segregated Southern churches from Christianity; they segregated Southern minds from honest thinking; and they segregated the Negro from everything."

— From "Our God Is Marching On!," speech given at the conclusion of the Selma to Montgomery march, Montgomery, Alabama, March 25, 1965

A victory march begins through the streets of downtown Montgomery. March 25, 1965.

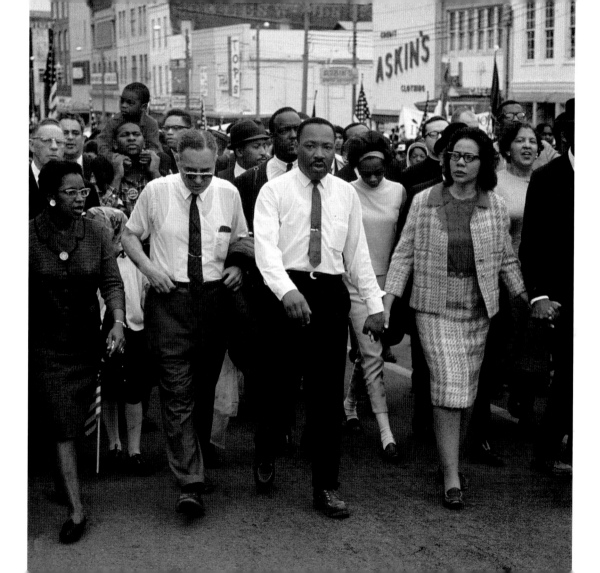

"Let us march on the ballot boxes until race baiters disappear from the political arena. . . . How long will it take? . . . How long? Not long, because the arc of the moral universe is long but it bends towards justice."

— From "Our God Is Marching On!," speech, given at the conclusion of the Selma to Montgomery march, Montgomery, Alabama, March 25, 1965

MLK speaks in front of the Alabama State House, the Cradle of the Confederacy, before a cheering crowd of fifty thousand supporters from all over the nation at the conclusion of the Selma to Montgomery march. March 1965.

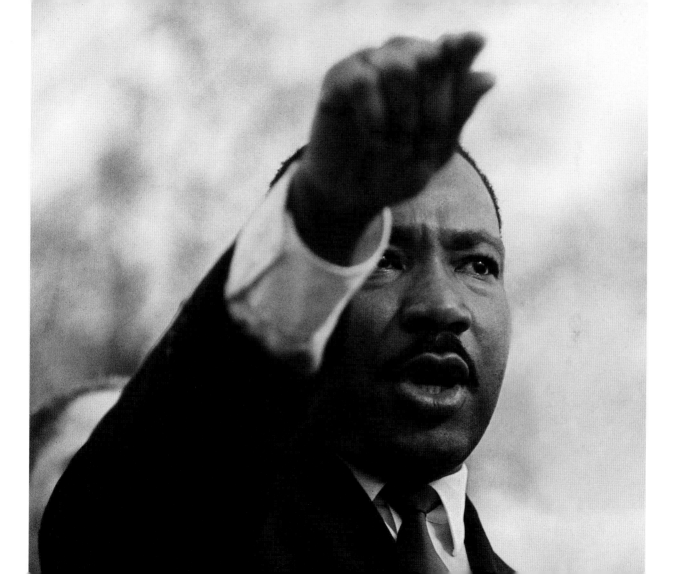

"We also come here today to affirm that we will no longer sit idly by in agonizing deprivation and wait on others to provide our freedom. We will be sadly mistaken if we think freedom is some lavish dish that the federal government and the white man will pass out on a silver platter while the Negro merely furnishes the appetite. Freedom is never granted by the oppressor. It must be demanded by the oppressed."

— From "Chicago Freedom Rally" speech,
July 10, 1966

MLK in his office with a Gandhi print. Atlanta, 1966.

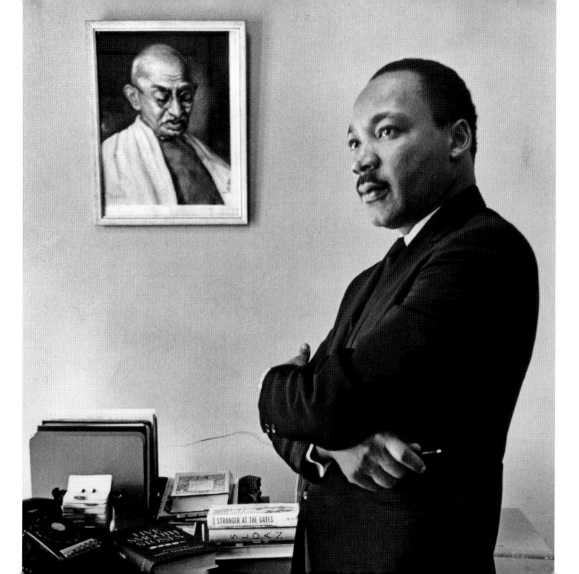

"I sometimes marvel at those who ask me why I am speaking against the war. We are called to speak for the weak, for the voiceless, for the victims of our nation, and for those it calls enemy, for no document from human hands can make these humans any less our brothers."

<div align="right">

— From "Conscience and the Vietnam War," in *The Trumpet of Conscience*, 1967

</div>

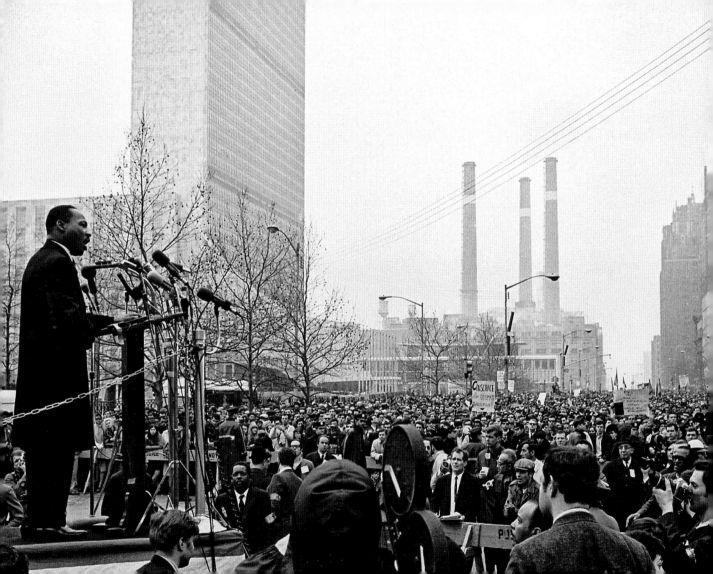

"Like anybody, I would like to live a long life. . . . I just want to do God's will. And He's allowed me to go up to the mountain. And I've looked over, and I've seen the promised land. I may not get there with you. But I want you to know tonight that we, as a people, will get to the promised land. And so I'm happy tonight. I'm not worried about anything. I'm not fearing any man. Mine eyes have seen the glory of the coming of the Lord."

— From "I've Been to the Mountaintop," speech given to striking sanitation workers, Memphis, Tennessee, April 3, 1968

MLK makes his last appearance on the public stage, speaking once again on behalf of the sanitation workers and their demand for just treatment. Before two thousand supporters at the Mason Temple on Wednesday, April 3, he makes his chilling, prophetic "I've Been to the Mountaintop" speech. Memphis, 1968.

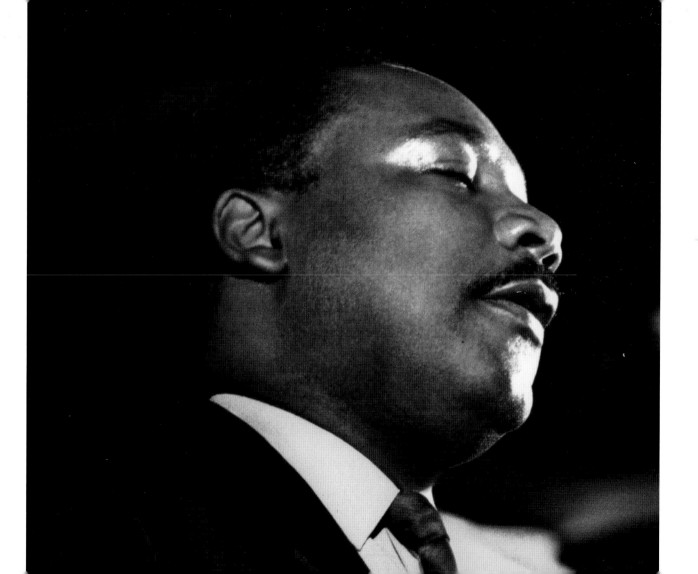

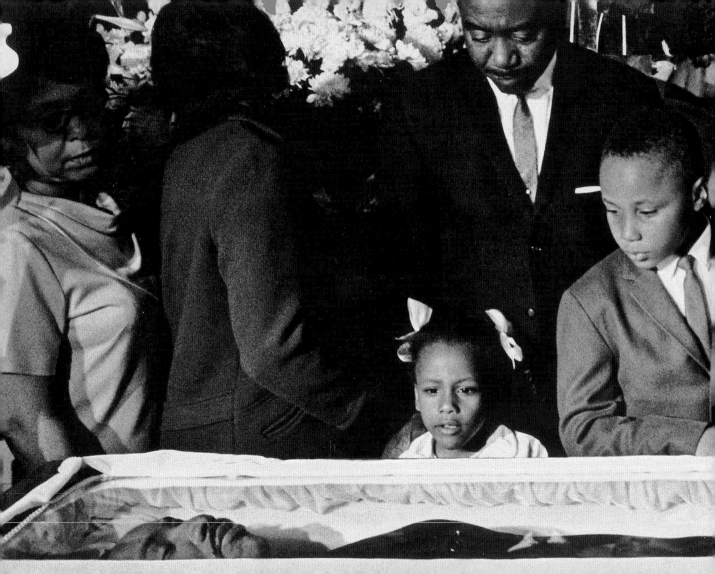

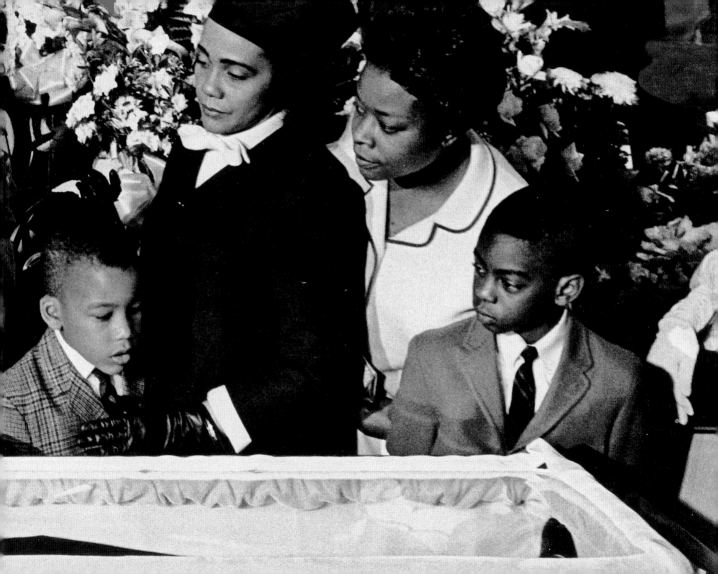

"If any of you are around when I have to meet my day . . . I'd like someone to mention . . . I tried to be right on the war question . . . that I did try to feed the hungry . . . to clothe those who were naked . . . to visit those who were in prison . . . to love and serve humanity. If you want to say that I was a drum major, say that I was a drum major for justice; say that I was a drum major for peace; I was a drum major for righteousness. . . . I just want to leave a committed life behind."

— From "The Drum Major Instinct," sermon delivered at Ebenezer Baptist Church, Atlanta, Georgia, February 4, 1968

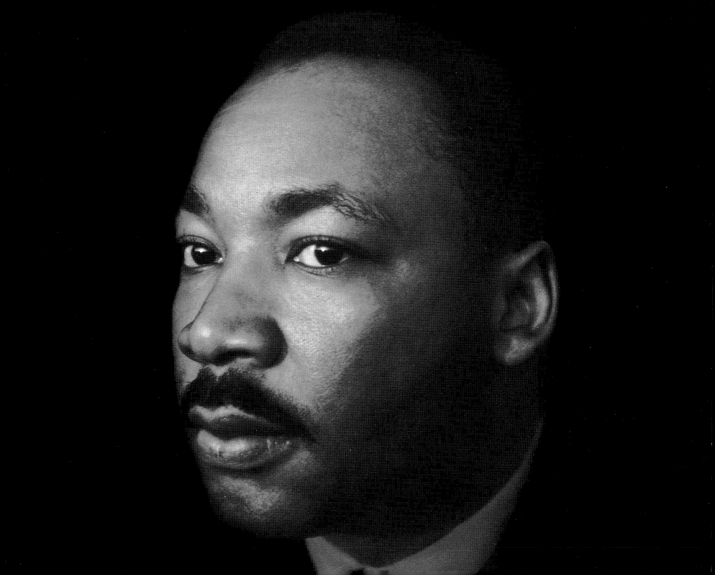

The King Years

1929 Martin Luther King, Jr., is born at noon on January 15, to Reverend and Mrs. Martin Luther King, Sr., at their 501 Auburn Avenue home in Atlanta, Georgia.

1944 MLK wins an oratory contest on April 17 with a speech entitled "The Negro and The Constitution." At age fifteen he graduates from Booker T. Washington High School and is admitted to Morehouse College (Atlanta) on September 20.

1948 MLK is ordained on February 25 at the age of nineteen as a minister at Ebenezer Baptist Church; his father is its pastor. MLK graduates from Morehouse College on June 8 with a degree in sociology. He enters Crozer Theological Seminary (Pennsylvania) on September 14.

1951 MLK receives bachelor of divinity degree from Crozer on May 8 and hears his first lecture on Gandhi. He enters Boston University for graduate studies in theology on September 13.

1953 Coretta Scott and MLK marry in Marion, Alabama, on June 18. Martin Luther King, Sr., officiates at the ceremony.

1954 MLK delivers his first trial sermon at Dexter Avenue Baptist Church in Montgomery, Alabama, on January 24. On October 31, he becomes its pastor.

1955 MLK is granted the doctorate of philosophy in systematic theology from Boston University on June 5. His dissertation topic: "A Comparison of God in the Thinking of Paul Tillich and Henry Wiseman." MLK is elected on August 26 to the executive committee of the Montgomery NAACP. After Rosa Parks's December 1 arrest for refusing to give up her seat on a segregated bus, he joins the bus boycott. On December 5, MLK is elected president of the Montgomery Improvement Association and becomes the bus boycott spokesman and leader.

1956 On January 26, MLK is arrested as part of a "Get Tough" campaign to intimidate the bus boycotters. On January 30, his home is bombed. He successfully pleads for calm to a vengeful crowd of neighbors gathered outside his home. On November 13, the Supreme Court rules that bus segregation is illegal. After black Montgomery walked for more than one year as part of the boycott, on the morning of December 21, MLK is one of the first passengers to ride on the newly integrated buses.

1957 MLK forms the Southern Christian Leadership Conference (SCLC) to fight segregation and achieve civil rights, and on February 14 becomes its first president. He and Coretta attend the midnight ceremonies in Accra on March 6, marking Ghana's independence. On May 17, in Washington, D.C., MLK speaks to a crowd of fifteen thousand at the Prayer Pilgrimage for Freedom to expand civil rights. On September 27, partially in response to the Prayer Pilgrimage, the U.S. Congress passes the first civil rights act since Reconstruction.

1958 MLK's first book, *Stride Toward Freedom*, is published on September 17. At a Harlem book signing on September 20, MLK is nearly killed when he is stabbed by an assailant. Along with other civil rights leaders, he meets on June 23 with President Dwight D. Eisenhower to discuss problems affecting black Americans.

1959 MLK and Coretta make a pilgrimage to India on February 2 and spend a month there as the guests of Prime Minister Jawaharlal Nehru to study Mahatma Gandhi's philosophy of nonviolence and to pay homage at his shrine. On November 29, MLK announces his resignation, effective January 1, as pastor of the Dexter Avenue Baptist Church to concentrate on civil rights work full time. He moves to Atlanta to direct the activities of the SCLC.

1960 On January 20, MLK moves to Atlanta and becomes co-pastor, with his father, at the Ebenezer Baptist Church. Lunch counter sit-ins begin on February 1 in Greensboro, North Carolina. The Student Nonviolent Coordinating Committee is founded on April 15 to coordinate student protests at Shaw University in Raleigh, North Carolina, and elsewhere. MLK is the keynote speaker at the event. In Atlanta, on October 19, MLK is arrested during a sit-in while waiting to be served at a restaurant. He is sentenced to four months in jail, but after intervention by then presidential candidate John Kennedy and his brother Robert Kennedy, MLK is released.

1961 On May 4, soon after the Supreme Court outlawed segregation in interstate transportation, Congress on Racial Equality (CORE) demonstrators begin the first Freedom Ride through the South, traveling as a racially mixed group on a Greyhound bus. On May 21, MLK addresses a mass rally in support of another group of Freedom Riders at a mob-besieged church in Montgomery, Alabama. In November, the Interstate Commerce Commission bans segregation in interstate travel in response to the Freedom Riders' protests. On December 15, MLK arrives in Albany, Georgia, at the request of the leader of the Albany protest, to desegregate public facilities there. The following day, at a demonstration attended by seven hundred protesters, MLK is arrested for obstructing the sidewalk and parading without a permit.

1962 Following the unsuccessful Albany, Georgia, movement, MLK is tried and convicted on July 10 for leading the march the previous December. He is arrested again on July 27 and jailed for holding a prayer vigil in Albany. He leaves jail on August 10 and agrees to halt demonstrations there. On October 16, he meets with President Kennedy at the White House.

1963 Sit-in demonstrations begin in February in Birmingham, Alabama. On April 3, the Birmingham campaign is officially launched. On Good Friday, April 12, Police Commissioner Eugene "Bull" Connor arrests MLK and Ralph Abernathy for demonstrating without a permit. During the days he spends jailed, MLK writes his historic "Letter from Birmingham Jail." On April 19, MLK and Abernathy are released on bond. During May 2-7, Birmingham police use fire hoses and dogs against the Children's Crusade. More than one thousand demonstrators, mostly high school students, are jailed. Protest leaders suspend mass demonstrations as negotiations begin on May 8. Two days later, the Birmingham agreement is announced. The stores, restaurants, and schools will be desegregated; hiring of blacks implemented; and charges dropped against the protesters. The day after the settlement is reached, segregationists bomb the Gaston Motel where MLK was staying. On May 13, federal troops arrive in Birmingham. The Birmingham protests prove to be the turning point in the war to end legal segregation in the South. On June 11, President Kennedy announces new civil rights legislation. Kennedy is the first U.S. president to say publicly that segregation is legally and morally wrong. On June 23, MLK leads 125,000 people on a Freedom Walk in Detroit. The March on Washington for Jobs and Freedom on August 28 is the largest civil rights demonstration in history with nearly 250,000 marchers. MLK leads the march for Jobs and

Freedom. The demonstrators demand an end to state-supported segregation and equal job opportunities. At the march, MLK makes his memorable "I Have a Dream" speech. On September 15 in Birmingham, a dynamite blast kills four black girls attending Sunday school at the Sixteenth Street Baptist Church. MLK delivers the eulogy for the four girls on September 22. President Kennedy is assassinated on November 22.

1964 On January 3, MLK appears on the cover of *Time* magazine as its Man of the Year. MLK is arrested protesting for the integration of public accommodations in St. Augustine, Florida, on June 11. James Chaney, Andrew Goodman, and Michael Schwerner—three civil rights workers who tried to register black voters during the Freedom Summer—are reported missing on June 21. MLK attends the signing ceremony of the Civil Rights Act of 1964 at the White House on July 2. The FBI finds the bodies of the slain civil rights workers buried not far from Philadelphia, Mississippi. On December 10, at age thirty-five, MLK becomes the youngest person to be awarded the Nobel Peace Prize.

1965 On February 2, MLK is arrested in Selma, Alabama, during a voting rights demonstration. Marching demonstrators are beaten at the Pettus Bridge by state highway patrolmen and sheriff's deputies on March 7. In reaction to the brutal beatings, President Johnson addresses the nation, describes the voting right act he will submit to Congress, and uses the slogan made famous by the civil rights movement: "We Shall Overcome." Federal troops are mobilized on March 21-25 to protect more than three thousand protestors marching from Selma to Montgomery. MLK, who led the march, addresses a crowd of more than twenty-five thousand supporters in front of the Cradle of the Confederacy, the Alabama State Capitol. On August 6, the 1965 Voting Rights Act is signed by President Johnson and MLK is given one of the pens.

1966 On January 22, MLK moves into a Chicago tenement to attract attention to the living conditions of the poor. In the spring, he tours Alabama to help elect black officials under the newly passed Voting Rights Act. On July 10, MLK initiates an effort to make Chicago an open city in regard to housing. James Meredith is shot during MLK's March Against Fear, on June 6. MLK and others continue the march. On August 5, as he leads a march through Chicago, MLK is stoned by a crowd of angry whites.

1967 On April 4, MLK delivers his first public antiwar speech at New York's Riverside Church. On April 15, in the shadow of the United Nations building, he delivers a speech against the war in Vietnam in what turns into the largest peace protest in the history of the country. The Justice Department reports that as of July 6 more than 50 percent of all the eligible black voters are now registered to vote in Mississippi, Georgia, Alabama, Louisiana, and South Carolina. The Supreme Court upholds a conviction of MLK by a Birmingham court for demonstrating without a permit. Starting October 30, MLK spends four days in a Birmingham jail. On November 27, MLK announces the inception of the Poor People's Campaign focusing on jobs and freedom for the poor of all races.

1968 MLK announces that the Poor People's Campaign will culminate in a march on Washington to demand a $12 billion Economic Bill of Rights guaranteeing employment to the able-bodied, incomes to those unable to work, and an end to housing discrimination. On March 18, MLK speaks to sanitation workers on strike in Memphis, Tennessee, and agrees to support them. On March 28, MLK leads a march that turns violent. He is appalled by the violence but vows to march again after the protestors learn discipline. On April 3, MLK delivers the "I've Been to the Mountaintop" speech at the Memphis Masonic Temple. At sunset on April 4, sniper James Earl Ray fatally shoots MLK as the civil rights leader stands on a balcony of the Lorraine Motel in Memphis. Ray is later convicted for the murder, which sparks riots and disturbances in 130 U.S. cities and results in 20,000 arrests. MLK's funeral, on April 9 in Atlanta, is an international event, and his coffin is carried on a mule cart followed by more than 50,000 mourners. Within a week of the assassination, the Open Housing Act is passed by Congress.

1986 On November 2, MLK's birthday, January 15, is declared a national holiday.

2011 The dedication of the Dr. Martin Luther King, Jr. Memorial takes place in Washington, D.C., August 26-28.